Butterfly Gardens

Coloring for Everyone

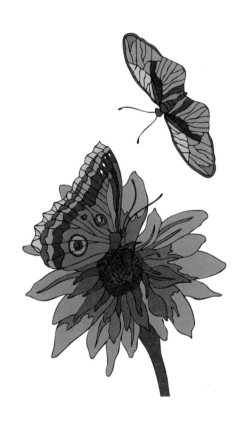

Racehorse Publishing

Copyright © 2016 by Racehorse Publishing, an imprint of Skyhorse Publishing, Inc.

Art credits:
Shutterstock/StevenRussellSmithPhotos (Intro image, monarch butterfly)
Shutterstock/Morphart Creation (Intro image, caterpillar in Lewis Carroll's *Alice in Wonderland*)
Shutterstock/aslysun (Intro image, chrysalis)
Shutterstock/Leena Robinson (Intro image, swallowtail butterfly)
Black-and-white illustrations by Madeline Goryl
Colorization by Timothy Lawrence

Racehorse Publishing books may be purchased in bulk at special discounts for sales promotion, corporate gifts, fund-raising, or educational purposes. Special editions can also be created to specifications. For details, contact the Special Sales Department, Racehorse Publishing, 307 West 36th Street, 11th Floor, New York, NY 10018 or info@skyhorsepublishing.com.

Racehorse Publishing is an imprint of Skyhorse Publishing, Inc.®, a Delaware corporation.

Visit our website at www.skyhorsepublishing.com.

10 9 8 7 6 5 4 3 2

Library of Congress Cataloging-in-Publication Data is available on file.

Cover design by Jane Sheppard
Cover artwork credit: illustration by Madeline Goryl; colorization by Timothy Lawrence
Text by Chamois S. Holschuh

Print ISBN: 978-1-5107-1227-0

Printed in the United States of America

Butterfly Gardens:
Coloring for Everyone

Some of nature's most beautiful and diverse creatures, butterflies and moths comprise the order of insects known as Lepidoptera (Greek for "scaly wing"). While moths are largely nocturnal, butterflies can be seen in the daytime, fluttering from flower to flower when the weather is warm. They range in size from the smallest specimens like the Western Pygmy Blue, whose wingspan measures a mere half inch, to the largest stunner Queen Alexandra's Birdwing, which lives in New Guinea and has a wingspan of up to twelve and a half inches! In North America, the most widely recognized butterfly is the monarch butterfly. This orange-and-black beauty summers throughout the United States and southern Canada, feasting on milkweed and other plants before heading south to Mexico for the winter. They are welcomed with a celebration in the state of Michoacán, which hosts the annual ten-day Festival of the Monarch Butterfly. Meanwhile, northwest of Mexico City lies the Monarch Butterfly Biosphere Reserve, a UNESCO World Heritage Site and nationally protected reserve of more than 200 square miles, set aside for the butterflies to rest and rejuvenate after their journey.

The variety of patterns and colors on their wings, as well as the folklore surrounding butterflies, make them an ideal study for artists and writers alike. Caterpillars, the larva stage, have been depicted in children's classics such as Lewis Carroll's *Alice in Wonderland* and Eric Carle's *The Very Hungry Caterpillar*. In Walt Disney's *Bambi*, courting butterflies are one of the first signs of spring—the animal kingdom's mating season so adorably termed in the film as "twitterpating." Indeed,

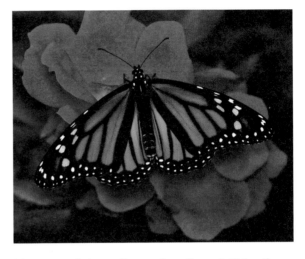

The monarch butterfly travels as far as 3,000 miles to spend the winter in Mexico.

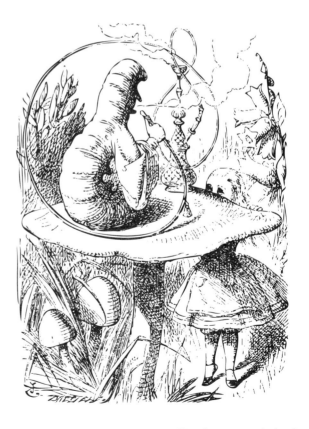

The Caterpillar in Lewis Carroll's *Alice in Wonderland*.

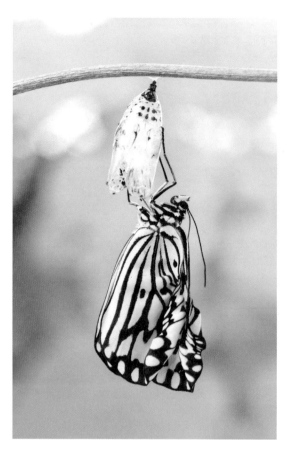

A butterfly emerges from its chrysalis and slowly unfurls its wings for the first time.

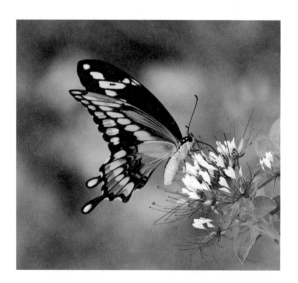

Swallowtail butterflies get their name from the distinctive "tails" on their wings, making them similar to the swallow bird family.

butterflies have long held the artist's eye. The Romans depicted butterflies as souls in sculpture. Further back, about 3,500 years ago, they appeared in Egyptian art. In the ancient Aztec city of Teotihuacan, temples, buildings, and jewelry featured the winged creatures. Among the Aztecs, it was a commonly-held belief that certain species were the reincarnations of deceased warriors. This concept spread to Mayan civilizations as well. In Japanese folklore, a butterfly may be regarded as the representation of a human soul, whether the person is dead or alive. Even the Greek word for butterfly—psȳchē—primarily means "soul" or "mind." The Greek goddess of the same name was often depicted with butterfly wings. Clearly, the concept of these elegant insects as symbols of the human soul appears to have been a global thought.

With all of these artistic examples to draw from, we can think of no better subject for this coloring book. Now, you too can explore the variety and intricacies of one of nature's most ornamental creatures. There are pre-colored versions of each design to provide guidance if you like, but you may also let your imagination fly free and explore all the possibilities you can conjure. The pages are perforated, so you can remove the black-and-white designs for more comfortable coloring and place them on display when you're finished. Toward the end of the book, you'll find color bars where you can test your palette. Take your inspiration from nature or draw from the depths of your own creativity. The pages of this coloring book are just waiting for you to complete their metamorphosis into beautiful works of art.

1

2

3

4

6

5

7

8

11

9

10

11

12

13

14

15

16

17

18

19

20

21

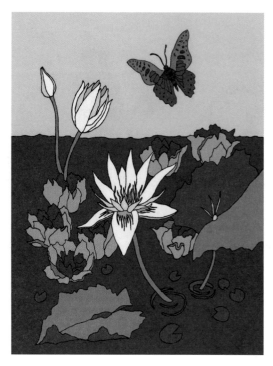

22

23

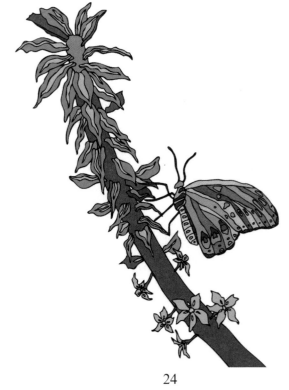

24

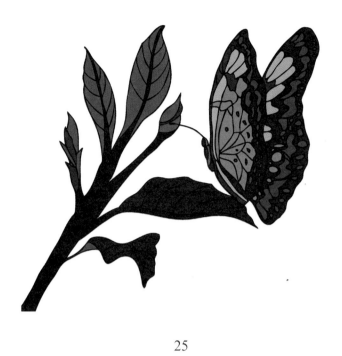

25

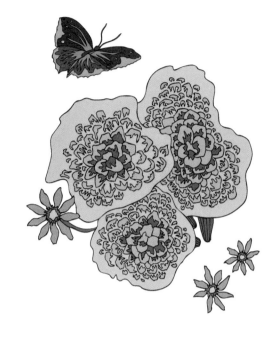

26

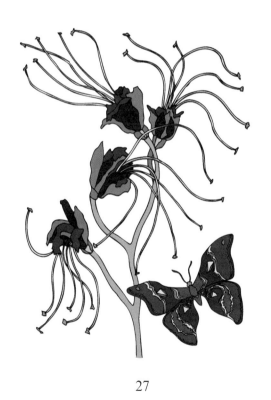

27

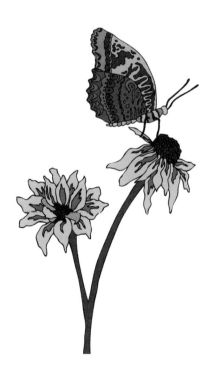

28

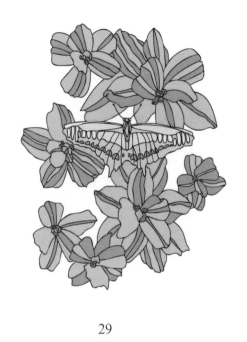

29

30

31

32

33

34

35

36

37

38

39

40

41

42

43

44

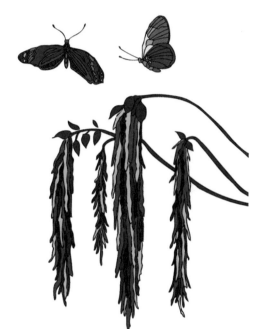

45

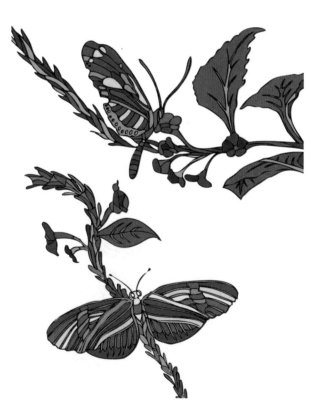

46

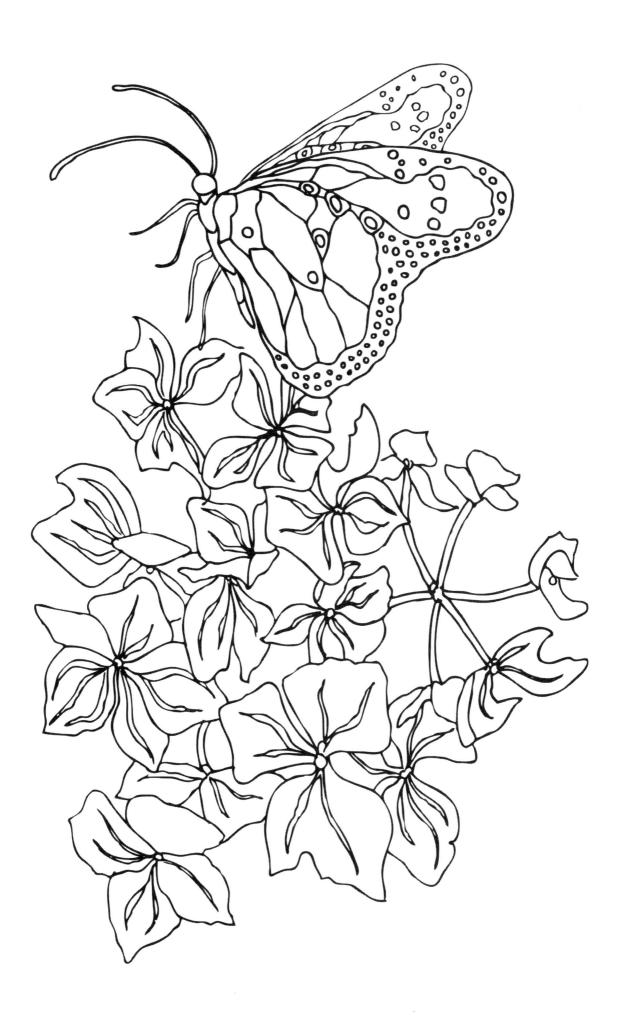

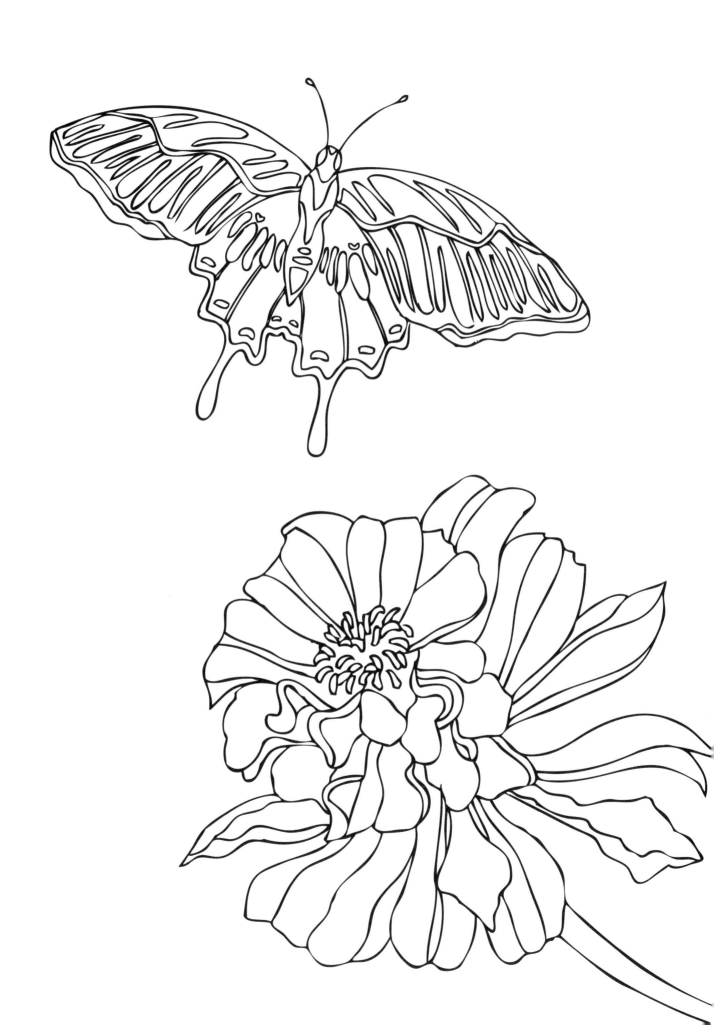

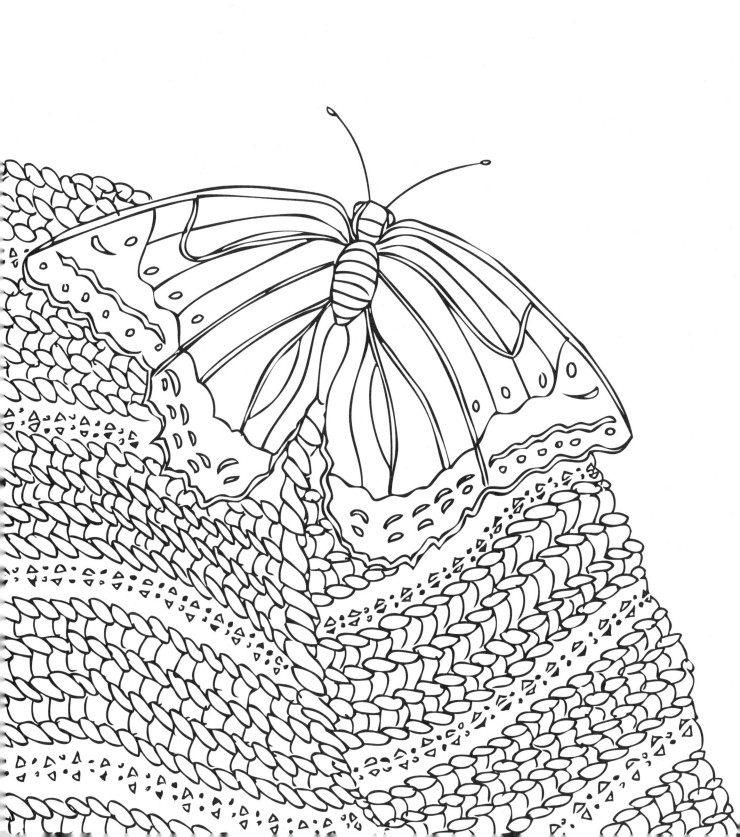

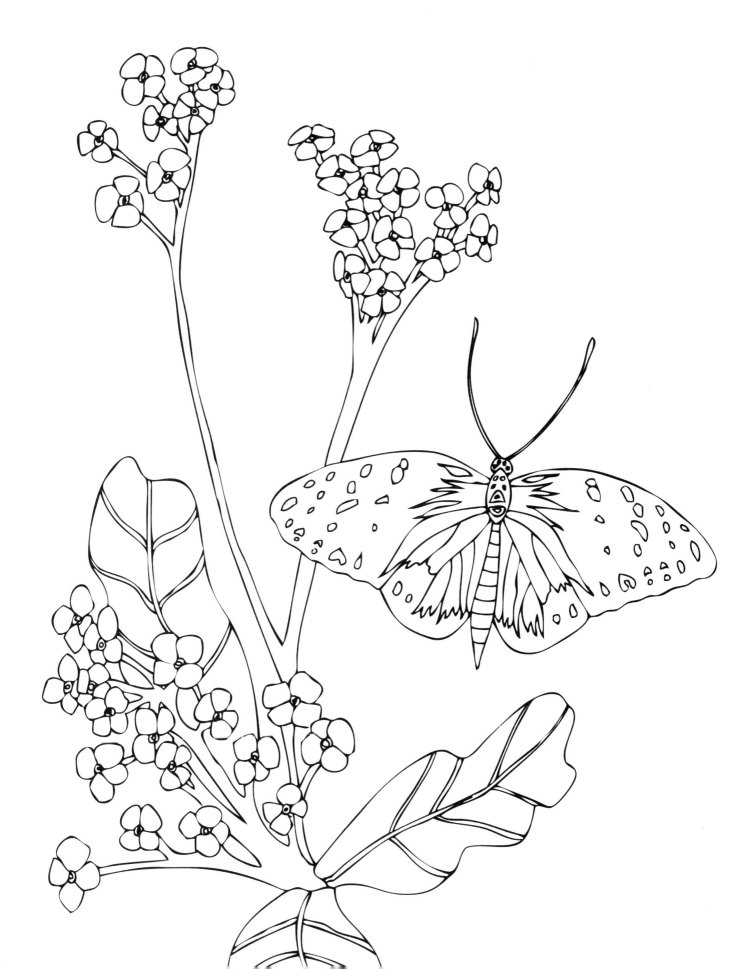

Color Bars

Use these bars to test your coloring medium and palette. Don't be afraid to try unique color combinations!

Color Bars

Color Bars

Also Available from Skyhorse Publishing

Creative Stress Relieving Adult Coloring Book Series
Art Nouveau: Coloring for Artists
Art Nouveau: Coloring for Everyone
Curious Cats and Kittens: Coloring for Artists
Curious Cats and Kittens: Coloring for Everyone
Exotic Chickens: Coloring for Everyone
Mandalas: Coloring for Artists
Mandalas: Coloring for Everyone
Mehndi: Coloring for Artists
Mehndi: Coloring for Everyone
Nature's Wonders: Coloring for Everyone
Nirvana: Coloring for Artists
Nirvana: Coloring for Everyone
Paisleys: Coloring for Artists
Paisleys: Coloring for Everyone
Tapestries, Fabrics, and Quilts: Coloring for Artists
Tapestries, Fabrics, and Quilts: Coloring for Everyone
Whimsical Designs: Coloring for Artists
Whimsical Designs: Coloring for Everyone
Whimsical Woodland Creatures: Coloring for Artists
Whimsical Woodland Creatures: Coloring for Everyone
Zen Patterns and Designs: Coloring for Artists
Zen Patterns and Designs: Coloring for Everyone

The Dynamic Adult Coloring Books
Marty Noble's Sugar Skulls: Coloring for Everyone
Marty Noble's Peaceful World: Coloring for Everyone

The Peaceful Adult Coloring Book Series
Adult Coloring Book: Be Inspired
Adult Coloring Book: De-Stress
Adult Coloring Book: Keep Calm
Adult Coloring Book: Relax

Portable Coloring for Creative Adults
Calming Patterns: Portable Coloring for Creative Adults
Flying Wonders: Portable Coloring for Creative Adults
Natural Wonders: Portable Coloring for Creative Adults
Sea Life: Portable Coloring for Creative Adults